THE LITTLE BOOK OF
Contemplative Photography

Published titles include:

The Little Book of Restorative Justice by Howard Zehr

The Little Book of Conflict Transformation by John Paul Lederach

The Little Book of Family Group Conferences, New-Zealand Style
by Allan MacRae and Howard Zehr

The Little Book of Strategic Peacebuilding by Lisa Schirch

The Little Book of Strategic Negotiation
by Jayne Seminare Docherty

The Little Book of Circle Processes by Kay Pranis

The Little Book of Contemplative Photography by Howard Zehr

The Little Book of Restorative Discipline for Schools
by Lorraine Stutzman Amstutz and Judy H. Mullet

The Little Book of Trauma Healing by Carolyn Yoder

The Little Book of Biblical Justice by Chris Marshall

The Little Book of Restorative Justice for People in Prison
by Barb Toews

El Pequeño Libro De Justicia Restaurativa by Howard Zehr

The Little Book of Cool Tools for Hot Topics
by Ron Kraybill and Evelyn Wright

The Little Book of Dialogue for Difficult Subjects
by Lisa Schirch and David Campt

The Little Book of Victim Offender Conferencing
by Lorraine Stutzman Amstutz

The Little Book of Healthy Organizations
by David R. Brubaker and Ruth Hoover Zimmerman

The Little Book of Restorative Justice for Colleges and Universities
by David R. Karp

The Little Books of Justice & Peacebuilding present, in highly accessible form, key concepts and practices from the fields of restorative justice, conflict transformation, and peacebuilding. Written by leaders in these fields, they are designed for practitioners, students, and anyone interested in justice, peace, and conflict resolution.

The Little Books of Justice & Peacebuilding series is a cooperative effort between the Center for Justice and Peacebuilding of Eastern Mennonite University (Howard Zehr, Series General Editor) and publisher Good Books (Phyllis Pellman Good, Senior Editor).

THE LITTLE BOOK OF
Contemplative Photography

Seeing with wonder, respect, and humility

HOWARD ZEHR

Good Books

Intercourse, PA 17534
800/762-7171
www.GoodBooks.com

Acknowledgments

I want to express my appreciation to those who read this manuscript, or parts of it, and gave feedback, especially Ervin Stutzman, Joseph Babu Ayindo, and participants in my classes and workshops.

Thanks also to Lynn Shiner for suggesting one of the additional exercises in the Exploring the Ordinary exercise (Chapter 3) and to Lucy O'Meara who offered the questions in the Meditating with Light exercise (Chapter 5) when she was my spiritual director.

Tracey King was of great assistance in obtaining permission to use quotations. Thanks also to Delphine Martin for her careful editorial eye.

The author gratefully acknowledges the numerous authors and publishers who granted permission to reprint excerpts in this book.

Excerpts from *The Mind's Eye: Writings on Photography and Photographers* © Henri Cartier-Bresson are used by permission of the publisher, *Aperture*, New York, 1999. Excerpts from *The Shape of Content* by Ben Shahn, pp. 63, 70, are reprinted by permission of the publisher, Cambridge: Harvard University Press, Copyright © 1957 by the President and Fellows of Harvard College, © renewed 1985 by Bernarda B. Shahn. An excerpt from *Crossing Open Ground* by Barry Lopez reprinted by permission of SLL/Sterling Lord Literistic, Inc. Copyright 1988 by Barry Lopez. Excerpts from *Why People Photograph* © Robert Adams are used by permission of the publisher, *Aperture*, New York, 1994.

Every effort has been made to trace and contact copyright owners. We apologize for any inadvertent omissions or errors.

All photography by the author, including the front cover.

Design by Dawn J. Ranck

THE LITTLE BOOK OF CONTEMPLATIVE PHOTOGRAPHY
Copyright © 2005 by Good Books, Intercourse, PA 17534
International Standard Book Number: 978-1-56148-457-7
Library of Congress Catalog Card Number: 2005015872

Library of Congress Cataloging-in-Publication Data

Zehr, Howard.
The little book of contemplative photography : seeing with wonder, respect, and humility / Howard Zehr.
 p. cm. -- (The little books of justice & peacebuilding)
 Includes bibliographical references.
 ISBN 1-56148-457-1 (pbk.)
 1. Photography--Social aspects. 2. Self-culture. 3. Meditation--Study and teaching. I. Title. II. Series.
 TR147.Z44 2005
 770--dc22 2005015872

Table of Contents

For me the camera is a sketch book, an instrument of intuition and spontaneity, the master of the instant which, in visual terms, questions and decides simultaneously. In order to "give a meaning" to the world, one has to feel oneself involved in what one frames through the viewfinder. This attitudes requires concentration, a discipline of mind, sensitivity, and a sense of geometry—it is by great economy of means that one arrives at simplicity of expression. One must always take photographs with the greatest respect for the subject and for oneself.

— Cartier-Bresson[1]

1.
Getting Started

Photography is not what's important. It's seeing.
The camera, film, even pictures, are not important.

— Algimantas Kezys[2]

Why this *Little Book?*

This is the age of photography. Daily we are bombarded—overwhelmed, really—with images. Slick advertisements, sensational news photos, dazzling entertainment that seems to recognize no boundaries, hidden cameras capturing our embarrassing moments: we often become cynical about the power of photography to do good.

Yet when properly conceived and conducted, photography can accomplish much that is positive. Photos can, for example, reveal what is hidden; they can tell important stories, preserve memories, stimulate dialogue, introduce people to one another, help to build community. I have long been interested in all of these uses, but these are not what this book is about, or at least not directly.

Rather, this is about how we might use the medium of photography to stimulate our imaginations, to develop our intuitive and aesthetic sensibilities, to gain new insights. It is an invitation to stop and look and be refreshed. In order to do this, it asks us to "re-image" how we envision and carry out photography.

Although this is not a meditation book in the usual sense, it proposes an attitude toward photography that in Chapter 2 is characterized as contemplative. In doing so, it does suggest that photography can serve as a medium for reflection and meditation, perhaps as a form of prayer.

This book is included in *The Little Books of Justice and Peacebuilding* series because seekers of justice and peace are often so committed to their cause that they take too little time to reflect and to appreciate the world around them. Such practitioners may also have cultivated their rational, analytic side to the neglect of equally important intuitive and visual ways of knowing.

> This book is about photography as play, not as work.

But the same can be said of most of us: by slowing down to reflect and meditate, by heightening our visual awareness and our imaginations, by cultivating receptivity and a more holistic way of knowing, we can renew ourselves while gaining new insights into ourselves, the creation, and the creator.

I must make a confession: I have written this book in part to encourage myself to do these very things more regularly. Although my main vocation has been in the justice arena, photography has been an essential part of my life for more than 30 years. In previous books and documentary or journalistic projects, I have used photography to try to pursue my justice concerns. Initially I was drawn to photography, I believe, because it was a counter to the linear, analytic ways of knowing that were drummed into me by higher education. Through photography I sought to develop more balance. And photography has indeed provided an opportunity to develop and express my aesthetic impulses.

But I am driven by a need to produce some sort of end product. It is difficult for me to allow myself to simply enjoy and appreciate photography as a process. I have needed to be deliberate about approaching photography as a kind of meditative and spiritual discipline.

I have used some of the ideas and exercises presented in this book in classes or workshops. However, by forcing myself to structure this as a book, I am also providing a framework and encouragement for my own ongoing spiritual discipline through the medium of photography.

When I was younger, I often was frustrated in my attempts to be deliberate about meditation. Somehow the disciplines and approaches to which I was introduced simply didn't seem to work for me. I assumed it was my fault, that there was something wrong with me, until I began to read about the correlation between personality types and meditative approaches.

I learned that my entree to meditation often has to be visual. I have since worked with several spiritual directors who gave me assignments that drew upon visual ways of knowing and, through this, I found my way. Photography emerged as an avenue of refreshment and insight for me, and thus this book.

About this book

This book is intended for both the novice and the experienced photographer. It is designed to help us rethink the medium of photography and to use it to heighten our visual awareness and our imaginations. These exercises offer new insights into yourself and your world or, at minimum, provide a breather in the midst of a busy life.

For the experienced photographer, they may offer a way to get out of a rut or to enjoy the process and the medium

without so much concern about the end product. The act of seeing and photographing can become an end in itself. This is about photography as play, not as work.

Each of the following chapters explores a particular theme. Each begins with reflections on that theme, then includes a series of suggested exercises. While the exercises are offered with an individual in mind, some of them can be used or adapted for use in workshops or classrooms. You also might want to consider teaming up with a friend so that you can share experiences and reflect on each assignment together.

Often when reading I copy into my journal short quotations that speak to me in some way. I include a number of such quotations throughout this book in an attempt to make these essays less of a monologue and to provide insights that might serve as additional possibilities for reflection.

Only a few photos are included in this book, and these are images intended to clarify points in the text. It may seem strange that a book about photography would be largely without photos. Indeed, I was tempted to include some of my own photographs, but I feared the purpose of this book might be lost. This is a book about *process* more than *product*. It is about your photography, not mine.

Equipment and knowledge

The exercises in this book require very little knowledge of photography and minimal equipment. The emphasis is on seeing and experiencing rather than how to photograph or produce a "fine print."

You will need access to a camera. It could be as simple as a disposable or homemade pinhole camera. A small "point-and-shoot" (unfortunate terminology, as we shall

see) will do well. A more sophisticated camera will give you more control, but if you are put off by technology, it will also offer more challenges that may get in the way of experiencing photography meditatively. I've also found that I'm likely to carry a small camera more often than a larger, more complex camera, and thus have it available when I see something interesting.

> The shadow-reality of the black and white image in the "straight" photograph . . . invites us to become the world it re-presents. Some would say that it invites us to imagine the real for ourselves.
> — Richard R. Niebuhr[3]

Because of its instant results, a digital camera is ideal for these exercises. I've found myself using photography as a meditative discipline more readily now that I can make an image, then immediately put it on my computer and contemplate it there. Even if you don't have a computer, you can view your images on a television by using a connecting cable that usually comes with the camera.

You may want to consider doing some or all of the exercises in black and white rather than in color. With black-and-white images, it is easier to remember that we are looking at a photographic image. Black-and-white images represent a kind of abstraction. Without the realism of color, we often are encouraged to see things that we might not otherwise notice. Patterns, textures, shapes, and visual movements that we easily miss in color often are revealed more clearly in black and white.

Black-and-white images are especially useful for helping us to see and appreciate light.

With digital cameras, it is usually possible to set the camera for black and white or to convert the images from color to black-and-white with your photo software. (The conversion command in your software may be called "grayscale," "remove color," or "desaturate.") For film cameras—assuming you don't have your own darkroom—I suggest you use one of the newer color-processed "chromogenic" black-and-white films (e.g., Ilford XP2 or Kodak B&W). These can be processed at any color lab or drug store along with color film. When they are machine-printed on normal color paper, their color cast may range from a pleasant warm tone to an objectionable green or magenta. Many labs, however, also offer prints on black-and-white paper at a slightly higher cost.

In most cases, you should not use flash for these exercises as it will overpower and ruin whatever light is present in the scene; this is especially true for Chapters 2 and 5. For dark subjects, you may need to use a tripod or something to brace your camera (e.g., the back of a chair). Otherwise, the shutter speeds may need to be too long to allow you to hold the camera steady.

With film cameras, you may want to use a film with a high ISO/ASA (a measure of film or sensor receptivity) in order to allow shorter shutter speeds. In fact, I use 400-speed film for most of my work (I find that the film speed of most black-and-white film is overrated. I suggest you set your ISO/ASA to about 250 with 400-speed film.) On digital cameras, you may want to increase the ISO. Be aware, though, that ISOs of 200 and especially 400 or more in digital cameras will usually increase the "noise," i.e., the appearance of tiny grain-like spots. For most of these exercis-

es, however, this will not be a significant problem as the quality of the final print is not what is most important.

Journaling

The value of these exercises will probably be increased if you journal during or after the exercise. The act of writing often helps us to think more clearly, and the written record provides a way to go back over time and observe how your experiences and insights have developed.

I suggest that you make or purchase a journal specifically for these exercises. You may want to consider inserting photos from the exercises as you go, either by gluing them in, using plastic sleeves, or, if you are digitally printing your own photos, using a loose-leaf notebook and printing your photos on larger paper that can be punched and inserted as pages. Alternately, if you are using a digital camera, you may wish to journal on your computer and keep your photos there. If you are using a word processing program, you can even insert photos into your journal. (For Microsoft Word, the commands are Insert > Picture > From File.)

> The meaning
> of the images,
> of the results
> of the process . . .
> is not so terribly
> important.
> What is useful,
> and worth
> relating,
> is the pleasure
> of the process,
> and its ability
> to clarify vision.
> — Steven J. Meyers[4]

For the first exercise in this chapter, you will need no camera at all.

Exercise: "Tuning up" our eyes

Purpose:
- To heighten your visual awareness of the world around you.
- To begin to select and abstract from the visual richness of our surroundings.
- To become aware of the impact of such selection and framing.

Problem: We tend to become immune to our surroundings, failing to be aware of the visual richness inherent in our settings.

Activity: This assignment has two parts. They should be done sequentially, one right after the other.

Part I:

Pick a familiar and comfortable environment: your living space, your workspace, a quiet place in a garden or park. Spend 15 minutes carefully observing that space from as many angles as possible, taking notes of what you observe: the objects, their placement and interrelationships, the light, etc.

Part II:

Cut a rectangular hole (perhaps 4″ x 6″ or 5″ x 7″) in an 8½″ x 11″ piece of cardboard. Use the frame as you would a camera, looking through it, moving it around, and noticing how various ways of framing things change what and how you see. Again, keep notes.

Reflection/discussion

- In Part I of the exercise, what, if anything, new did you see? In what ways did you see differently?
- In Part II, what changed as you began to see in "frames" and to make selections? Did you observe any differences in relationships between objects when you put a frame around them? Did you notice anything that you didn't before?
- In what ways does imposing a frame limit your view, and in what ways does it actually amplify your vision?
- Does this framing process and its implications suggest any analogies for other parts of your life, e.g., your life choices or your faith?

Additional suggestion: "Dry photograph"—that is, make a series of photographs using your camera but without actually using film. This is a way of extending the above exercise while at the same time getting more comfortable in handling your camera. By "dry photographing," you will reduce your tendency to be very selective and make each frame count.

Exercise: I see/feel/think

Note: This exercise can be used in conjunction with many of the following exercises.

Purpose:
- To develop a holistic visual awareness.
- To encourage the process of photography as a discipline and a source of insight.
- To begin to make photographic vision a habit or discipline.

Problem: Rarely do we spend enough time with an image to "mine" all of its visual, emotional, and spiritual potential. Rarely are we aware of its impact on the emotional as well as the intellectual level. Too often our tendencies to judge and evaluate get in the way of appreciating what we see.

Activity:
- Discipline yourself to make at least one photograph each day.
- Once a week, spend at least 10 minutes with one of the photographs.
- As you do, consider three topics in this order:
 1. *I see* (Describe: examine each object, each detail, the light, etc. Then associate: what are you reminded of by the shapes, juxtapositions, etc.?)
 2. *I feel* (What do you feel as you look at the image?)
 3. *I think* (Interpret and analyze.)
- Keep a journal about this and any insights you gain.

Reflection/discussion:
- What was most enjoyable about this exercise? What was most difficult?
- What happens when you withhold judgment until the end of the process?
- What, if any, new insights have you gained—about yourself, photography, the creation, the creator?
- This exercise emphasizes the process more than the end product of photography. What, if any, challenges did this pose for you?

Quote for reflection: *Description is revelation. Seeing is praise.* —Chet Raymo[5]

Additional suggestion: Pick a written passage that uses visual imagery—a poem or some scripture. With your eyes closed, try to visualize the imagery the passage suggests. What is the setting? Where are you in relationship to the object you are visualizing? What is your relationship to the object? What, if any, new meaning emerges from this?

2.
Changing Our Lens

. . . the most dominant characteristic of the photographer since the 1880s has been his aggression.

— Bill Jay[6]

Think for a moment about the words and metaphors that we use when we talk about photography:

We *take* a photograph.

We *aim* our camera.

As *snapshooters* we *shoot* a picture.

Professional photographers go on a photo *shoot*.

The words and images we use are predominately aggressive and acquisitive.

This militaristic image of photography is reflected in the design and use of photographic equipment. Cameras often are designed to be held in front of the face like a mask. The camera's lens protrudes, aiming at the subject like a weapon. If not a weapon, the camera and lens blocking the photographer's face often look like an intrusive, voyeuristic eye. No wonder that people—including many photographers—are often so uncomfortable in front of a camera.

This image of photography is reinforced by the way photography is marketed. A famous lens manufacturer announces that its "new snub-nose zoom shoots to kill." An ad

for a photo lab has a cowboy holding a camera like a gun against a western sky with a "wanted" poster on the wall behind him. A store for professional photographers advertises that the company "is responsible for over 2,876,431 shootings." It touts its "arsenal" of equipment and promises that their service will "blow you away." Photo magazine articles evaluate and compare cameras in a "shoot-out." Small automatic cameras are called "point-and-shoot" cameras.

Not surprisingly, the way we actually practice photography often reflects this image of photographer-as-aggressor. We steal photos with a telephoto lens without the subject's consent, collecting them like trophies. We treat photos as commodities with no input from the subjects about how they are portrayed, how the image is edited, or where it is used. We use the camera as a way to avoid interaction with our subjects. We create photographs that emphasize the "otherness" of our subjects, often perpetuating racial and gender stereotypes.

This image of photography-as-aggression has a long history, but it is not inevitable. Photo historian Bill Jay points out that for the first three decades of its history—from the 1850s through the 1880s—photography had a much gentler and respected image.[7] Not until the introduction of small handheld cameras in the 1880s did the image change as people began to clandestinely photograph others. In 1885, one writer offered a solution: "There is but one remedy for the amateur photographer. Put a brick through his camera whenever you suspect he has taken you unawares. And if there is any doubt, give the benefit of it to the brick, not to the camera."

In a parody of Kodak's slogan, "You push the button—we do the rest," a poet tells the story of a young maiden secretly photographed while reading in a hammock. Her two

strapping brothers happened to see this. "They rolled up their sleeves, Threw off hat, coat and vest—The man pressed the shutter and they did the rest!"

The photographer-as-aggressor, and especially as sexual aggressor, became a kind of cultural icon with the 1960s movie, *Blow Up.* Especially significant is a scene in which the photographer, standing over a writhing model, photographs her in a way that can only be seen as a sexual act. The movie's photographer was imitated by many, and the movie helped to shape the self-image of many photographers—and of photography—since that time.

In short, the language and metaphors of photography are predominately aggressive, predatory, acquisitive, imperialistic. But they do not have to be this way. In fact, this metaphor of *taking* an image does not accurately reflect the photographic process itself.

When we photograph, we do not actually reach out and take anything. A camera is basically a dark box with a receptor (film or digital sensor) on one side and a small opening on the other. Light reflected from the subject is projected through the opening by the lens onto the receptor opposite it. When we do photography, we receive an image that is reflected from the subject. Instead of photography as taking, then, we can envision it as *receiving.* Instead of a trophy that is hunted, an image is a *gift.*

To photograph in this spirit is a matter of opening ourselves to receiving. Like meditation or contemplation, photography-as-receiving requires us to cultivate an attitude of receptivity, an openness to what might be given to us. Such photography is more like meditation or a spiritual discipline than a hunt.

The following chart contrasts the two "lenses" for viewing photography and its possible implications, some of

which will be explored in later chapters. You may wish to keep this chart in mind as you go through the exercises in this book.

Photography as *taking*	Photography as *receiving*
images *taken*	images *received*
images as *booty*	images as *gifts*
camera as a *weapon*	camera as a *receiver*
photography as *conquest*	photography as *contemplation*
subject as an *object*	subject as *co-creator, collaborator*
image as *mine*	image as *ours*
responsibility to *self*	responsibility to s*elf and others*
obligation to *my* "truth"	recognition of the *subject's* "truth"
focus on *"otherness"*	focus on *interconnectedness*
perpetuates stereotypes	*challenges* stereotypes
an attitude of *judgment*	an attitude of *wonder*
concern for *control*	openness to *surprise, mystery*
exclusive focus on *final product*	*process* important
photography as *exposé*	photography as *revelation*
photography as *aggression*	photography as *respect*

> The most
> compelling images
> have come
> from remaining
> receptive
> to what
> the place
> has to offer.
> — Fazal Sheikh[8]

The following exercises ask you to begin "re-imaging" the way you think, talk about, and practice photography. This will require you to be conscious of the language and metaphors you use but also of how you envision photography in your conscious and unconscious mind.

The photography-as-aggression metaphor is deeply embedded in our culture and consciousness; to change our "lens" takes time and deliberate effort. This change in perspective is essential, however, if we are to experience photography as contemplation or meditation.

Exercise:
Photograph without viewfinder

Purpose:
- To make it easier to experience photography as receiving rather than taking.
- To increase your openness to surprises and spontaneity.

Problem: When a camera is put in front of someone's face, both the photographer and the subject are more likely to experience photography as taking or aggression. In her book *On Photography,* Susan Sontag has called photography "a tool of power,"[9] and looking through the viewfinder encourages this by maximizing control over the image.

Activity: Make a series of photographs without looking through the viewfinder. Using autofocus or manual focus, set your camera for a focal distance of about 8 feet. Hold it at chest or waist level, perhaps at the end of its strap. Direct the camera toward something you want to photograph and try to visualize what the camera is "seeing," but do not look through the viewfinder. As you photograph, imagine that the photograph is receiving the image. Make photographs of inanimate subjects but also of people in some kind of activity. Journal about the experience and the resulting images.

Reflection/discussion:
- Was it easier to conceive of photography as receiving by not looking through the viewfinder?
- How do you think the resulting images were different than if you had used the camera normally?
- What, if anything, was unexpected in the resulting images?
- What are the advantages as well as the disadvantages of photographing in this way?
- What challenges—psychological or emotional, as well as technical—does photographing this way pose for you?

Quote for reflection: *I rarely look through the viewfinder, and then only to check the focal length of the lens I am using I certainly believe that my photographs, when viewed and composed using the viewfinder, seem to be flat and passive compared with those composed without, whose energy is still retained.* —Keith Cardwell[10]

Additional suggestion: If you have a digital camera with an LCD viewer, you may find that it is easier to envision photography as receiving when using it instead of the regular viewfinder. This is especially true if the LCD screen flips out so that you can look down into it while photographing. Similarly, medium-format cameras with a waist-level finder can make it easier to imagine receiving rather than taking an image.

Exercise: Receiving an image

Purpose: To develop the habit of receiving rather than taking images.

Problem: A *taking* approach to photography is deeply ingrained in us through marketing, the media, and the aggressive, acquisitive nature of western culture.

Activity: Find or create a subject that interests you in a place where you won't be disturbed. It could be a landscape, a still life, an ordinary object in your house, a (patient!) close friend or loved one. Look at the subject for a while, imagining that your eyes are receiving the image (which they are). Now make a series of photographs of this subject using the viewfinder, but each time imagining the reflected image being received by the camera. Try to use the camera in a way that is consistent with this. Do not use flash.

Reflection/discussion:
- Did you experience the process differently when you thought of photography as receiving an image of the subject?
- Do you think it made any difference in the resulting images?
- Did you find yourself using the camera differently? If so, how?

Additional suggestion:
- Whenever you photograph, try to visualize yourself as receiving rather than taking.

- Examine a variety of photographs in books or magazines, trying to determine which attitude or "lens" on photography the photographer seems to have. Does she or he seem to have taken or received the image? What makes you think so?

3.
Practicing Mindfulness

*I begin to see . . . an object when I cease to under-
stand it.*[11]

— Henry David Thoreau

To fully experience photography as a way of seeing and
as a meditative exercise, an attitude of genuine recep-
tivity and openness is required. Some call this approach
mindfulness. Here is one description by Ozzie Gontang:

> *Mindfulness or being mindful is being aware of your pre-
> sent moment. You are not judging, reflecting or thinking. You
> are simply observing the moment in which you find yourself.*[12]

Daniel Goleman describes it like this:

> *Mindfulness entails breaking through stereotyped percep-
> tion. Our natural tendency is to become habituated to the
> world around us, no longer to notice the familiar In
> mindfulness, the meditator methodically faces the bare facts
> of his experience, seeing each event as though occurring for
> the first time. He does this by continuous attention to the
> first phase of perception, when his mind is receptive rather
> than reactive.*[13]

Mindfulness involves a rejection of preconceived ideas
and expectations combined with a cultivated attitude of

openness to whatever we might receive. It is the opposite of concentration in which you focus your attention on one thing. This approach is similar to that of Native-American hunters who are said to have conditioned themselves to see everything but focus on nothing. In that way, anything that appeared, even at the very edges of peripheral vision, would catch their attention.

Mindfulness is similar to the Zen principle of seeking to approach a situation with a "beginner's mind," without the expectations, preconceptions, and ideas gained through prior experience. Thus mindfulness is also about being aware of and appreciating the ordinary, of being open to beauty and insights in the commonplace. As photographer/painter Ben Shahn said, it is "finding the extraordinary in the ordinary."[15]

Photographer Elliott Erwitt put it like this:

> To me, photography is an art of observation. It's about finding something interesting in an ordinary place I've found it has little to do with the things you see and everything to do with the way you see them.[16]

> When you're thinking about what to do, you don't have enough attention left to see what's around you. Ordinary things, when really seen, make extraordinary photos. Such photos seem to make themselves. They seem like presents that we're given.
> — David Vestal[14]

The word "mindfulness" comes originally from the Buddhist tradition and for many of us seems a somewhat para-

doxical term. To be sure, it suggests being mindful of, or being attentive to, which is one dimension of mindfulness. However, the term "mindfulness" also requires a disciplined "idling" of the conscious mind, a suspension of mental activities such as judgment and analysis. "Watchfulness" is an alternate term that conveys some of this meaning.

In his book *Will and Spirit: A Contemplative Psychology*, Gerald May contrasts "willingness" with "willfulness."[17] In his view, an attitude of willingness involves an attitude of receptivity, a surrendering of self, an openness to revelation. It is saying yes to the mystery of being alive and present. An attitude of willfulness, on the other hand, reflects a concern to master, to control, to impose one's own interests, needs, and understandings. It is saying "No," or perhaps "Yes, but" Willingness, then, is another term that conveys some of what is meant by mindfulness.

Hindrances to receptivity

Many aspects of our lives and habits hinder this kind of mindful approach to the world. The following are 13 common hindrances that get in the way of real receptivity.[18]

1. An acquisitive, aggressive approach to photography.
2. Preoccupation with technique or with the technical side of photography.
3. Preconceptions and pre-established rules about what to photograph and how to compose.
4. A discriminating or judging attitude that constantly labels, categorizes, and evaluates subjects or ourselves.
5. Concern about the approval and disapproval of others or about what some "authority" has said.

6. Perfectionism and/or a goal orientation; over-concern about an end product.
7. An appreciation for the extraordinary and a devaluing of the ordinary.
8. Being so used to the world around us that we take it for granted.
9. Over-reliance on the "head" and on the intellect rather than on intuition and feeling.
10. Preoccupation with ourselves; too much self-consciousness or self-criticism.
11. Lack of spontaneity; an obsession with prediction and planning.
12. A need to be in control of the process and to impose one's concept and viewpoint.
13. An intolerance for the unidentifiable or unknowable.

Of course, some of these "hindering" factors or attitudes do have value. There is a time to plan, to have goals, to use the head, to make judgments. In a holistic, receptive approach to photography, however, these dimensions have their place: in balance, and often later in the process. For example, if you seriously pursue photography, chances are you will need to evaluate your work, choosing which photographs are strongest and which subjects seem most relevant. But if this discriminating, goal-oriented approach is where you start, your vision and understanding will—in the language of the Chinese approach called Tao—become constricted. You will limit the possibilities of photography as a source of insight into yourself and the world.

Quote for inspiration: *When [I'm] out photographing, it's with a sense of play: no bounds are in sight, anything is possible, and the unexpected welcome.* —Chip Forelli[19]

Exercise: Exploring the ordinary

Purpose:
- To make you more aware of the visual richness of ordinary objects and scenes.
- To help overcome biases and judgments about what is worth looking at and photographing.
- To recognize how varying angles and settings affect how we see and interpret what we see.

Problem: We often overlook things that we experience as ordinary or everyday. We tend to make preconceived judgments about what is worth looking at or photographing, valuing the "picturesque" or "spectacular" and failing to recognize many of the visual possibilities around us.

Activity: Pick an ordinary object.
1. Look at it in as many ways as you can. Squint at it. View it from unusual angles. Observe it in a mirror or against an unusual background. Look at it for a long time. While looking at it, let yourself daydream or free associate. Keep notes about what you see and experience.
2. Now, photograph it in a variety of ways, varying angles, backgrounds, lighting, etc. Try not to make judgments about whether the resulting images will be worthwhile, concentrating instead on your immediate reactions to and feelings about the various views.
3. Examine the resulting photographs and compare them to your journal notes from Activity 1 above.

Reflection/discussion:
- Did looking at the subject in this way help you to see it differently? How? Why?
- Did any new meanings or insights emerge as you spent time with the object and with the resulting image?

Quote for reflection: *But revealing is the right word for certain photographs at certain times. In the moments we become confluent with them, they are vessels of revelations. And these revelations are credible, because they take place in the lights and shadows of the ordinary world without annulling its ordinariness. It is a mode of revelation of which we hear nothing or little from theologians today.*

— Richard R. Niebuhr[20]

Additional suggestions:
- Cultivate an awareness of seemingly ordinary or everyday objects and views. Try not to take things for granted or to be judgmental of their visual quality.
- Set out to photograph without a specific subject in mind, remaining open to whatever seems to present itself.
- Carry a camera with you every day as a reminder to keep this awareness alive.
- Photograph in an unlikely place where there seems to be nothing obviously photogenic. Reflect on the images. Do any new insights or meanings emerge?
- Using the self-timer on your camera and, with the camera on a tripod or other support, make a series of photographs of yourself. Vary the angle and the

lighting; perhaps use a candle for one. Photograph yourself reflected in a mirror or pond. Reflect on the differences the various settings and lighting make, even though you remain the same person.

Exercise: Break the rules

Purpose: To help you become conscious of and move beyond the "rules" you have heard and learned about how to photograph.

Problem: Consciously or unconsciously, we have all learned many rules about when and how to photograph. These limit our ability to be open to new possibilities.

Activity:

Try to think of some of the rules you have heard or assumptions you have made about what and how you should photograph. For example, "Always photograph with the sun over your shoulder." "Don't photograph at mid-day." "Put your subject in the center," or "Don't center your subject." "You can't photograph in the dark without flash." "Don't photograph against the sun." Write as many of these as you can in your journal.

Now, make a series of photographs in which you consciously break as many of these rules, and in as many ways, as you can. Reflect on the resulting images.

Reflection/discussion:
- Do your photographs suggest that the "rules" were worth taking seriously? What happened when you did not?
- Were there any surprises? What do they suggest about how you want to photograph in the future?

Additional suggestions:
- Reflect on the meaning and implications of each of the "hindrances" mentioned in this chapter. To what extent do they apply to your inclinations, tendencies, and assumptions?

4.
An Attitude of Wonder

. . . wonder is the fuel which sustains vision.[21]

— Steven J. Meyers

Doubt everything, instructed the philosopher Descartes, until you can find something that is certain. Believe only what cannot be doubted. For him, the one thing that couldn't be doubted was the axiom, "I think, therefore I am."

This "way of knowing" that seeks certainty through skepticism and criticism has deeply influenced western culture. In some ways it has served us well; without this critical approach, without a suspicion of "unknowing," the scientific revolution might not have been possible.

> Knowledge is an island surrounded by a sea of mystery.
>
> — Chet Raymo[22]

But an attitude of doubt conditions us to approach experience with an attitude of judgment and a discomfort with uncertainty. It often causes us to dwell upon deficiencies rather than strengths, on criticism rather than affirmation. It can constrict the way we encounter the world, numbing us to the extraordinary and closing us off from many possibilities. It interferes with mindfulness. And it is embedded deeply in western psyches and culture.

31

In his book *Returning to the Teaching,* Rupert Ross contrasts western with Native American worldviews and explores the ways the differing worldviews shape, and are shaped by, language.[23] In comparison to these indigenous languages, Ross notes, English relies more heavily upon nouns to name and categorize. We quickly label things.

> It is a characteristic of the aesthetic process, and of aesthetic vision, that specific conscious intent is tempered with an acceptance of surprise and the unexpected. A desire for the resolution of ambiguity is mixed wonderfully with a love of the ambiguity which keeps reappearing.
> — Steven J. Meyers[24]

Moreover, our labels are often value-laden, connoting an opinion or judgment implying something was good or bad or we liked it or did not. Nouns serve as labels and tend to be static, implying an unchanging state or condition. The English language thus seems both to reflect and encourage an attitude of judgment and an emphasis upon certainty and finality.

Native languages, on the other hand, rely more on verbs than nouns. By emphasizing action words, their outlook tends to focus more on change, processes, and relationships rather than static, inherent qualities. The language, and the worldview behind it, is less likely to pass quick judgment and is more open to unexpected and emerging qualities in the known as well as in the unknown. This approach does not emphasize doubt as a way of knowing.

Years ago my undergraduate philosophy professor, Delbert Wiens, began the semester with an observation that I never forgot and that has deeply influenced me. Instead of Descartes' stance of doubt, he urged us to approach life and the world in an attitude of wonder. An attitude of wonder begins with appreciation rather than suspicion, acknowledging the limits of what we know. It is an openness to possibilities. David James Duncan defines wonder brilliantly:

> . . . *wondering is unknowing, experienced as pleasure.*[25]

An attitude of wonder suggests a stance of openness, a beginner's mind, an embrace of surprises, an ability to live with a degree of uncertainty and unknowing. An attitude of wonder requires that we look anew at the familiar, that we stop taking the world around us for granted. An attitude of wonder acknowledges how little we really know. An attitude of wonder is essential if we are truly to experience the creation and the creator.

Earlier I mentioned Gerald May's distinction between willfulness and willingness. These two approaches are, he says, connected to our attitude toward wonder. While willfulness ignores or negates wonder, willingness bows in reverence toward it.[26]

My friend Dick Lehman, a well-known potter, captures this spirit of wonder when he talks about his Shino pottery, a form of ceramics originating in 16th-century Japan:

> *To choose Shino, is to make so many other choices as well . . .*
> *to choose learning, more than understanding;*
> *to choose marveling, more than knowing;*
> *and to choose to become a receiver, more than a maker*[27]

An attitude of wonder and openness, of "marveling, more than knowing," requires an appreciation of mystery.

"Our growth depends on openness to experiences of mystery," says spiritual director Pat Koehler.

An attitude of wonder, which acknowledges a role for mystery and unknowing, also acknowledges and appreciates the reality and power of ambiguity. Indeed, it has been argued that ambiguity is the basis for art that is enduring. Without ambiguity, art tends to become propaganda. Ambiguity implies a lack of closure, an inability or unwillingness to tie up all the loose ends, a recognition that all of the contradictions in life cannot be resolved. Ambiguity creates and reflects an element of uncertainty and mystery. It allows space for art to have more than one level of meaning and to speak to different viewers in different ways.

Speaking of a famous Cartier-Bresson photo of a child playing in the rubble of war, one commentator has observed, "Yet for its part the photograph is reticent under our gaze. It offers us not a declarative statement but rather a riddle: one fleeting instant in which the powers of life and death are arrayed in a startling, fragile truce."[28]

Mystery and ambiguity are present in many photographs that speak to us. The identity, the context, perhaps the meaning of a photograph—or elements in a photograph—may be interpreted in more than one way. Photographs without words to give them context are often ambiguous. This ambiguity can be problematic, but it may also be a source of strength and emotional appeal.

Ambiguity poses questions:

What is it?
Where is it?
What does it mean?

An Attitude of Wonder

An attitude of wonder, an openness to mystery, a tolerance of ambiguity are all essential to a meditative approach to photography and to photography as a form of meditation.

We are called to openness, and sin is the closing off of ourselves from mystery. Closing ourselves to mystery is closing ourselves to God.[29]

—Pat Koehler

To keep both wonder and vision alive, we must learn, once again, to be children.[30]

—Steven J. Meyers

Exercise: Exploring abstraction

Purpose:
- To help you understand the role of abstraction in mystery and ambiguity.
- To encourage you to explore the ways mystery and ambiguity affect the impact and meaning in an image.

Problem: We often take for granted the world around us, finding it difficult to approach it with the awe that it deserves. So, too, we usually take for granted the meaning of photographs that are literal representations of the world. On the other hand, an image that is too abstract may lose its meaning and power.

Activity: Choose a subject: an object in nature, a common household object, perhaps a patient friend. Photograph the subject in such a way that the image becomes almost unrecognizable, or so its identity becomes obscure and it becomes an abstraction. You may want to do this by moving in very close and photographing only fragments, or by moving the subject from its context, or by working with the lighting. Then photograph it in such a way that it still remains highly abstract but contains enough clues that it doesn't completely lose its identity. You might do this by making sure the image contains some clue to its identity or at least the materials it is made of, by changing the lighting, or by showing its context.

Look at the resulting images from all angles—upside down, sideways—and notice what happens. Show these images to a friend, asking her/him to identify the subjects and soliciting her/his reactions.

Reflection/discussion:

- In what ways do these abstract images create mystery and ambiguity? Did they make you see anything differently?
- What different understandings of the subject matter are possible due to this abstraction? What new insights, and what misunderstandings, might result?
- How do your feelings, associations, and/or meanings change when viewing the subject in this more mysterious or ambiguous version?
- Which images seem strongest to you—those that are truly abstract, those in which the image contains a clue to the identity or the reality of the subject, or those in which the identity is unmistakable? Why?

Quotes for reflection:

. . . *the presence of ambiguity allows visual representation of nature to create a broader range of responses in a viewer than a careful and obvious articulation of details might.*[31] —Steven J. Meyers

. . . *I am not interested in making abstract photographs, but I am interested in photographing the abstract in nature.*[32]
 —Ralph Gibson

To abstract is to draw out the essence of a matter.[33]
 —Ben Shahn

. . . *life consists of questions and I want to get people to ask themselves questions. . . . What one sees in a photograph is not as interesting as the questions the photographer poses through it.*[34] —Bourbacar Touré Mandémory

Additional suggestions:

- Photograph a subject in both color and black-and-white. What do you see differently in the black-and-white version? In what ways is this version an abstraction?

- Look at a news photograph from a newspaper or magazine. Without its identifying caption, what different interpretations of the event or people are possible?

Exercise:
Finding mystery in the familiar

Purpose: To help you explore the mystery that is present around us.

Problem: We tend to take the familiar for granted, failing to marvel at the beauty, power, and meaning to be found there.

Activity: Pick a familiar place or space (you may want to use the same space as in the "Tuning up our eyes" exercise in Chapter 1). Try to look at it with a beginner's mind, as if you were seeing it for the first time. Expose an entire roll of film (or the digital equivalent), concentrating only on lines, shapes, textures, details, and relationships between forms, light, and colors.

Examine the resulting images in a different space than where you made the images. Explore what new meanings they might suggest and what questions they

raise. Then return to that space with the images and compare them to the actual space you photographed.

Reflection/discussion:
- In what ways did you see differently when you photographed with this mindset and in this manner?
- To what extent do these images create mystery and ambiguity? Do any new meanings or interpretations result from these images?

Additional suggestion: Find a book of photographs by Edward Weston or his son Brett Weston (or another photographer who works with close-up images of nature). Spend time with some of their close-up images, exploring the role of mystery and ambiguity and the various levels of meaning that emerge. Use "I see/feel/think" questions from Chapter 1. What do the images remind you of, or what associations arise?

5.
Seeing the Light

This is the play of light.
It enters through the
borders of being. It
occupies each particle
of the air. The air becomes
shining seed. It squirms.
It dances.[35]

— Fiona Farrell

The word "photograph" is derived from two Greek roots: *photo* or light, and *graph*, to write. The very first book of photographs, published in 1844 by inventor Fox Talbot, was titled *The Pencil of Nature.* To photograph is to draw with light. To photograph is to receive and hold light; a photograph is "frozen light." Light is the essence of photography. Without light, there is no photography.

Light and its absence—shadow—are the essential building blocks of all images. An ability to be aware of and use light is probably the most important attribute in photography and is essential to what Steven Meyers has called "aesthetic vision."[36]

Light—along with shadow, the counterpoint to light—plays many visual roles. Light defines and reveals. It can convey drama or quietude. It can show texture or hide it. It can suggest warmth or coldness. It captures our attention, leads our eye.

Light—along with shadow—has many emotional connotations as well. It can convey hope as well as fear, sensuality as well as coldness, revelation as well as mystery. Our associations with light can lead our heart and minds in many directions.

This chapter is intended to encourage you to increase your awareness of light in photography but also in the world around you. Attention to light will not only dramatically heighten your overall visual awareness and improve your photographic eye; as we shall see in the next chapter, metaphors of light and dark provide rich possibilities for meditation and insight as well.

I encourage you, therefore, to spend significant time with the exercises in this chapter in order to tune up your competency and consciousness of light. If you are already an accomplished photographer, you may want to go directly to the exercises beginning on page 47.

Characteristics of light

Light is considered to have five basic characteristics: quantity, quality, direction, contrast, and color.

The *quantity* or level of light often concerns beginning photographers the most. Is the light bright or dim? Is there enough light or too much? The aperture and shutter of a camera must be adjusted to provide the correct "exposure,"

Characteristics of light:

quantity or level
quality: hard, soft
direction
contrast
color

that is, the proper amount of light that reaches the film or digital sensor. In a manual camera, you have to do this with the aid of a light meter. In an automatic camera, this is done for you.

In low light, you'll need to steady the camera, e.g., with a tripod, to minimize the effect of camera shake because of long shutter speeds. In low light, "fast" lenses (that is, with wide maximum apertures) will allow you to photograph with higher shutter speeds. The quantity or level of light is clearly important but is primarily a technical issue and less important to the "look" of the image than the other qualities.

Perhaps the most emotive characteristic of light is its *quality*—that is, its "hardness" or "softness." The hardness and softness of light falls along a continuum. On one end is light that is highly directional and comes from a relatively small source (relative to the subject). A spotlight at some distance from the subject is a hard light. So, too, is direct sunlight because it is far away from the earth, and thus relatively small.

Hard light creates bright areas with hard shadow lines. Transitions from light areas to dark areas are often abrupt. Hard light can be dramatic, theatrical, and, in the right position, can throw well-defined shades and provide clear definition of forms. It can also be quite unforgiving.

"Soft" light, on the other hand, is diffuse light. This is light created by a relatively large light source and/or diffused by traveling through clouds or cloth. The light on an overcast day is diffuse light, as is light coming through sheer window drapes or reflected off light walls.

Diffuse light can gently suffuse the subject with light. Transitions from light to dark are gradual, with soft-edged shadows. Diffuse light often provides better "modeling," or

three-dimensionality, because the light gradually falls off as the distance away from the light source increases.

For example, if you photograph someone with a hard light (such as the sun) over your shoulder, the photograph will show some modeling or three-dimensionality because there will be small, hard shadows. However, the lighter areas are likely to look flat. With diffuse light over your shoulder, the transitions from light to dark will be more

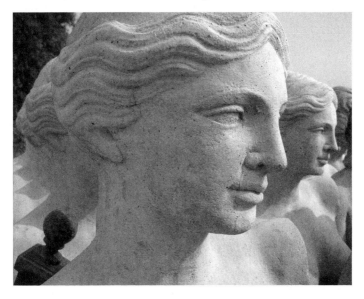

As can be seen from the hard-edged shadows, the light in this photo is hard, direct sunlight. It is coming from the side and slightly behind the figure. As the light flows across the face from the right to left side, the gradation of shadows emphasizes the three-dimensionality of the figure. The sidelight also emphasizes the texture of the figure because the tiny raised areas throw small shadows. If the light had been coming from the front, as with an on-camera flash, the face would have appeared flat, with little three-dimensionality, and the texture would have been minimized.

gradual, usually giving a more subtle sense of three-dimensionality, while also appearing more flattering.

As the above suggests, the *direction* of light also has major implications. Sidelight tends to show up textures because the light skims rough surfaces, causing rhythms of light and shadow that suggest three-dimensionality. Sidelight also maximizes three-dimensionality of the subject. Backlight may cause the subject to be outlined in light but, if there is insufficient light from the front, may cause the subject to look too dark. Direct frontal light lights the subject evenly, often minimizing three-dimensionality.

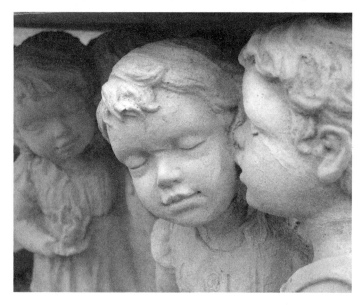

The light in this photo is relatively diffused, coming from a somewhat overcast sky. Shadow transitions are gradual, creating a soft, three-dimensional effect. The main light is coming from the upper left side, emphasizing the three-dimensionality of the figures. Because it is diffuse or "soft," it does not accentuate texture as much as the photo with direct sidelight on page 43.

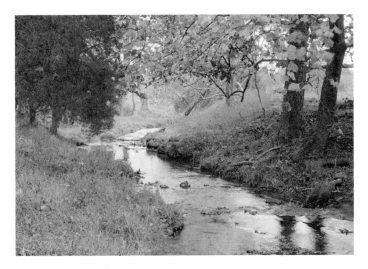

In this photograph of a creek flowing through a pasture, the overall contrast is quite high: there are large differences between the darkest and lightest areas, and the transition between them at points is quite abrupt. However, in some areas such as the grass, the local contrast is quite low: the differences between darkest and lightest areas in the grass are fairly minimal and the transitions between them gradual.

Contrast has to do with the differences between light and dark areas. A scene or image that has great differences between light and dark is said to be high contrast or "contrasty." A scene or image that has less significant differences and more gradual transitions is said to be softer or less contrasty. Photographers talk about "local contrast" and "overall contrast." Overall contrast refers to the extremes of light and dark in the image or scene as a whole. Local contrast refers to the extremes or transitions in some part of the scene or image.

Color is a characteristic of light that we often overlook because our eye makes automatic adjustments of which we

A Guide to exploring light

- Where is the light in the image?
- Where are the shadows?
- What is the source of the light?
- What characteristics does the light have (e.g., soft vs. hard, contrast, color)?
- What shapes, forms, movements does the light create or suggest?
- How does the light affect the movement of your eye?
- What are the emotional effects of these characteristics of light?

are unaware. Films and digital sensors are sensitive to light color. However, modern films are manufactured to be surprisingly forgiving, and the white balance on a digital camera attempts to make appropriate adjustments.

However, you may have noticed a yellow cast to photos taken indoors with tungsten light bulbs. This is because tungsten light is "warmer" than daylight. Similarly, sunlight at the very beginning or end of the day tends to be warmer. You may have heard photographers talk about the "sweet light" of the evening—light that is warmer and more diffuse than earlier in the day. Light color has some significance in black-and-white photography because film does not see color the way the eye does, but that is not so important here.

These characteristics of light convey a variety of meanings and emotions. First, though, it is important to become aware of light itself and this is the emphasis of the first exercise on pages 48-49. The second exercise (on pages 50-51)

will encourage you to explore emotions, meanings, and associations.

Suggested warm-up exercise: Spend some time looking at a well-known photograph or one that you think is especially effective, preferably a black-and-white one. Examine the light in the photo using the questions above on page 46. Pay special attention to the gradations of tones.

Exercise: Playing with light

Purpose: To become more aware of light and its characteristics.

Problem: Light has a powerful impact on how and what we see, yet we take it for granted. It takes training and practice to become aware of light and its effects.

You will need:
- An object that you can move around.
- A relatively dark space.
- One or more light sources. Ideally you should have available both a diffuse light source and a more directed or "spot" source. The diffuse source could be a window over which you place some sheer material. To make the light more diffuse, you can bounce it off a wall or white poster board. The spot source could be a flood or spotlight in a clamp or even a desk light.

Activity: Photograph your object in black and white in as many ways as possible by varying the light characteristics. Use only one light source at a time. Try shining the light from different directions (including lower and higher angles) by either moving the object or the light source. Use diffuse light as well as more directed light. Examine the resulting images, asking the guiding questions on page 46.

Reflection/discussion:
- What have you learned about light from this assignment?
- Which kinds of light do you prefer?
- In what ways do the various ways of lighting the subject suggest different interpretations or meanings?
- If you were to use electronic flash, would you see this as aggressive in any way?

Additional suggestions:
- Repeat the same assignment creating a portrait of someone you know and feel comfortable with.
- Make a series of photographs in which the subject is *light*. Try to disregard subject or content, concentrating instead on the light itself.
- Remind yourself to be aware of light—while you are driving or walking, as you listen to a public speaker, when you wake in the morning . . . and especially while photographing!

Exercise: Meditating with light

Purpose: To explore the impact and meaning of light for your own life.

Problem: We are often unaware of the power of light to speak to us.

You will need: This exercise can be done with a photograph, a painting, or a passage about light from a poem, from literature, or scripture.

Activity: Spend time with your chosen image or passage. First ask the "Guide to exploring light" questions on page 46. Then reflect on these questions:

- How does the light feel?
- Where does it enter?
- What words seem associated with the light or with its effect?
- What are the implications of these associations?
- What part of me connects to these?
- What is this saying to me?
- Might I somehow embody this light?

Reflection/discussion:
- Were you able to experience any new dimensions from the passage or image you used?
- Did you gain any new insights into yourself and/or your present concerns and priorities?
- Did this experience suggest anything about how you might affect others?

Additional suggestions:

- Find a poem or passage from literature or scripture that uses light. After reflecting on that passage, and using the questions above, make a photograph that suggests the qualities of light you see in the written words.

 Scripture passages using light: Psalm 104:1-4; 2 Peter 1:19; John 12:35-36; John 1:1-9. (See "Exploring your metaphors" exercise on page 59 for additional suggestions.)

- Use the following questions as an analytic tool when facing a decision or analyzing a situation related to photography:
 - Where is the light in this situation?
 - Where are the shadows?
 - What are the sources of the light?
 - What qualities does the light have?
 - How is the light distributed? (If you are using imaging software such as Photoshop, you can see how the various shades of light are distributed throughout the spectrum using the histogram. For any given shade or tone, the height of the graph indicates the number of times in the image that tone appears. Thus, for example, if there is a large hump toward the left edge of the histogram, the image is made up predominately of dark tones.)
 - What do your answers to these questions suggest or imply about the situation or your response?

6.
Exploring Metaphor

It is with metaphor that one must become comfortable if one wishes to see.[37]

—Steven J. Meyers

While you still have the light, believe in the light so that you may become children of light.[38]

—John the Apostle

In the previous chapter we explored light and shadow as physical realities, but light and shadow are much more than that; they also function as powerful metaphors. All knowing—whether rational or intuitive—involves metaphors, and photographic images often have important metaphoric dimensions. In fact, since a photo is something that stands for another reality, photography can be viewed as a metaphoric activity. It is important, therefore, to explore the function of metaphors in knowing and seeing.

Whenever we talk about things that we cannot see or touch, we inevitably do so by making a comparison to something that we can know more directly. Even when an object is directly perceivable, it is still often helpful to explore its meanings or workings by comparison or reference to other things. This is as true of science as of poetry, art, or religion.[39]

An analogy, a simile, and a symbol are all forms of comparison in which we explain or remind ourselves of something by referring to something else. In each of these comparisons, though, we are explicit that we are making a comparison: "The light flowed across the floor *like* liquid butter," or "This tree *symbolizes* new life." Metaphor is similar to these forms in that we use it to explain or understand one sort of thing in terms of another sort of thing; Colin Murray Turbayne, a linguist has called it "sort-crossing."

However, metaphor is different because when we make this comparison, we don't say we are doing it. In the biblical passage at the beginning of this chapter, for example, the writer helps us to understand and respond to divine revelation by making a comparison with light without saying he is doing so. His listeners knew—and we know—that light is not to be taken literally.

> . . . the way to know God has always been by way of metaphor . . .
> — Edward Lueders[40]

In my work with crime victims and offenders, I have observed that people in trauma—whether prisoners or victims—use many metaphors to try to understand and explain what they have gone through and where they are going. Otherwise, the experience is almost without words. Indeed, some therapists say that in working with traumatized people the challenge is to help them identify the metaphors of woundedness that dominate them and then to identify and replace them with metaphors of healing that can guide their recovery.

Because they are inevitable, yet unnamed, metaphoric comparisons have many interesting qualities. For example, while metaphors are very helpful in highlighting certain

characteristics, they can also hide other characteristics. That is, they may be misleading because the "match" between the two realities is never exact. God is not light, for example, but some of the qualities of light help us to understand God better. Nor is God male, even though male metaphors (e.g., God as father) are sometimes used. A problem arises when we forget that we are speaking metaphorically and equate that with reality. Once again, we are faced with paradox. As the author of the *The Clam Lake Papers* observes, "We are tricked by metaphors from cradle to grave, yet our best insights are caught in metaphors."[41]

This is not the place to explore the uses and misuses of metaphor. Nor is it essential here to make clear distinctions between the various forms of comparison such as analogy, symbol, and metaphor. For our purposes, we will use the term "metaphor" loosely, to include various forms in which one thing stands in for or is compared to another. What is important here is to be aware that all ways of knowing involve the "metaphorical imperative"[42] and that visuals have strong metaphoric elements and power. Indeed, the act of seeing almost inevitably involves metaphor. Meyers puts it like this:

> *Metaphor has been thought to be the private realm of the poet and artist. Rather than argue this truth, I choose to believe that seeing, for all of us, involves metaphor. To the extent that we see well, we are all poets and artists.*[43]

In photography and in visual perception generally, this metaphorical imperative works both ways. Explorations of elements in a photograph—a quality of light, a particular object, a juxtaposition, a pattern—may remind us of and help us to understand another reality. Awareness of light may help us understand the creator, for example, because our faiths inevitably use metaphoric language to understand the divine.

Cartier-Bresson's photograph of children playing in the rubble of war, cited earlier, may become a metaphor or symbol of hope. The image over my desk of a grieving mother and child after an earthquake in Armenia, made by my photographer friend Mark Beach, symbolizes for me the sorrow and tragedy that is part of life. An image I once made of the source of the mighty Susquehanna River—a spring flowing into a bathtub in a field that serves as a water tank for cows, then spilling over to begin a stream—reminds me that the restorative justice "river," with which I am associated, has many small sources.

On the other hand, exploration of the metaphors we read and use may help us to see more richly. For example, if we reflect on imagery used in a poem or scripture passage, it may help us see new dimensions and meanings in the images we choose to make. Meditating on a scripture passage such as the Song of Zachariah ("By the tender mercy of our God, the dawn from on high will break upon us . . ."[44]) has given me new appreciation of dawn light.

Awareness of metaphor is an essential part of meditative vision or photography.

The metaphor, then, is not simply a figure of speech. It is a habit of thought, one we must develop in order to see. The habit of metaphor allows us to see the large from the small, the pattern in chaos, that which is not expected, that which is expected, in new ways. Metaphor allows us to see with eyes expanded beyond the simply literal, the cataloguing of perceptions. Metaphor allows us to see relationships. Ultimately, it is the relationships which constitute nature, not collections of individual objects.[45]

—Steven J. Meyers

Quotations for reflection:

I think of the dignity that is ours when we cease to de- mand the truth and realize that the best we can have of those substantial truths that guide our lives is metaphori- cal—a story Beyond this, that the interior landscape is a metaphorical representation of the exterior landscape, that the truth reveals itself most fully not in dogma but in the paradox, irony, and contradictions that distinguish com- pelling narratives—beyond this there are only failures of imagination: reductionism in science; fundamentalism in re- ligion; fascism in politics.[46] —Barry Lopez

The two ways of knowing—reason and intuition, science (metrics) and art (rhythmics)—must work together in re- sponse to the metaphorical imperative *that is at the base of the human method. Maybe there is no truly human un- derstanding without both.*[47] —Edward Lueders

Exercise: Finding metaphors

Purpose:
- To explore the metaphoric dimensions of things around us.
- To practice identifying and communicating such metaphoric elements.

Problem: We are often unaware of the metaphoric and symbolic qualities in the world around us—and even of the metaphors and symbols that we use.

Activity: Photograph a subject in such a way that it seems to become, or suggest, a metaphor. This could mean photographing an object for its metaphoric qualities. For example, the shape or texture of a stone might suggest masculinity or femininity. Alternately, photograph a subject in such a way that it represents a symbol or has symbolic qualities for you.

You might want to make one photograph that explores a commonly understood metaphor or symbol, and another that is personal or that you create for yourself.

Reflection/discussion:
- Did this exercise make you more aware of metaphoric and symbolic possibilities?
- What were your challenges in this assignment and why?
- Artists often incorporate commonly understood symbols and metaphors in their work. Some artists,

however, create deeply personal metaphors or symbols. What are the strengths and weaknesses of personal symbols or metaphors—those that you create and that speak primarily to you—compared to recognized symbols and metaphors?

Additional suggestions:
- Try to become more conscious of the metaphoric qualities of things you see.
- Return to some of the images you made in Chapters 3 and 4, examining them for metaphoric qualities.

Exercise: Exploring your metaphors

Purpose: To become aware of and explore a common linguistic metaphor.

Problem: Our speech and thought relies heavily on metaphors. Yet we are usually unaware of these metaphors and their implications.

Activity: We use metaphors every day. When I say "I'm feeling down today" or "I am filled with emotion," I use spatial and container metaphors for feelings. We also use metaphors that characterize who we are, what we have experienced, or what our goals are. We constantly make such comparisons although we are usually unaware that they are metaphoric.

Identify a metaphor in your speech or the speech of others, perhaps from a written passage such as the newspaper. Reflect on the implications of this metaphor, then create a photograph that suggests, explores, or is otherwise inspired by this metaphor.

Reflection/discussion:
- Did you find it difficult to identify metaphors from everyday language?
- Does this make you more aware of the metaphors you use?
- Did the photographic exploration of the metaphor increase your insight into it?

Additional suggestions:

- The figurative language of poems, literature, and
 scripture makes frequent use of metaphors. Pick a
 passage using a visual metaphor that speaks to you
 and reflect on this metaphor, visualizing it in your
 mind. Reflect on what qualities it highlights (that is,
 helps to make clear), but also what qualities it might
 obscure or misrepresent. You may also want to use
 this metaphor passage as a focus for meditation or
 to make a photograph inspired by it.

 Suggested scriptures with light-related metaphors:
 2 Samuel 23:3-4; Hosea 6:3; John 8:12 and 12:35-36,
 46; Luke 1:78-79; Isaiah 9:2 and 42:16; Psalm 18:28.

- Practice identifying the metaphors you and others
 use in daily life.

7.
Making Meaning

In order to "give a meaning" to the world, one has to feel oneself involved in what one frames through the viewfinder. This attitudes requires concentration, a discipline of mind, sensitivity, and a sense of geometry—it is by great economy of means that one arrives at simplicity of expression.[48]

— Cartier-Bresson

Photography is receiving, but it is active—not passive—receiving. Photography is selection: we must select which images to receive and how to compose or organize them. Photography is not just about vision, but about selective vision, selective receiving. When we put a frame around an image, taking it out of its context as we do when we photograph, we are in fact constructing a version of reality. We are imposing a way of seeing, a meaning, upon the reality that we are receiving.

Mary Price entitles her collections of essays on the medium *The Photograph: A Strange, Confined Space,* pointing out that a photograph does not have a fixed, inherent, and self-evident meaning.[49] A photograph is never a simple record of reality.

Art commentator Weston Naef observes that it is no surprise that the art movement surrealism was drawn to pho-

tography because surrealism "feeds on unexpected juxtapositions and the love of found objects, which take on other meanings when placed in a new context."[50] Since a photograph is by nature an image out of context, it might be said that a photograph is inherently surreal.

The meaning which a photographer indends to convey is often ambiguous. How the photographer organizes the elements in the image, and the clues she or he gives about the context (in the image, through words), strongly affects the meaning of the photograph.

Photography involves creating order out of chaos, organizing visual elements to provide a coherence or meaning. Madeline L'Engle says "all art is cosmos, cosmos found within chaos."[51] Photographer Robert Adams puts it like this: "An artist, in other words, 'invents' from the confu-

I made the above photo in an airport, holding the camera on my lap and guessing the framing (see the "Photograph without viewfinder" exercise on page 19). Although composition plays some role, this photo is primarily about the content rather than the form.

In this photo, the content of the photo is the sea, rocks, and sky. However, the form is what gives the photo its appeal: the quality of light, the interplay of light and dark, the curving diagonal created by the flowing tide, the way our eyes are led into the photo by these qualities.

sion of life a simplification, a picture with more order than the literal subject apparently has, so as to suggest by analogy a wider coherence throughout life."[52]

Adams also comments that "the goal of art is to convey a vision of coherence and peace, but the effort to develop that vision starts in the more common experiences of confusion and pain."[53]

We create this meaning, this order, by what we select, how we select it, how we compose the elements within the frames of the image. Sometimes an image may focus primarily on content—the actual object or action in the photo. At other times, the emphasis may be more on the form—on the aesthetic qualities of the image. For example,

the focus may be on the interplay of light and dark, or lines, or the arrangement of objects in the photo. However, form and content are usually closely interrelated: the stronger the form, the more powerfully the photo connects or communicates. Photographer/painter/printmaker Ben Shahn has argued that "Form is the visible shape of content."[54]

> Form is thus a discipline, an ordering, according to the needs of content.
>
> — Ben Shahn[55]

Much has been written about form or composition. Some writers suggest "rules" of composition. It is important to be aware of how certain elements tend to function in an image—our eyes tend to be drawn to the brightest spots, for example, and diagonals or spirals tend to be more active than straight vertical or horizontal lines. But rules tend to get in the way of mindfulness.

Photographer Edward Weston said that in order to use our photographic vision to discover and reveal the world, we must keep our approach "free from all formula, art-dogma, rules and taboos." His definition of composition—"the strongest way of seeing"—is probably as useful as any.[56]

Arthur LaZar, a gifted photography instructor, often asks a question that I find most useful as a guideline to composition: "Where is the energy here?" Posing that question of a scene or image, I find, is often the key to figuring out what works and what does not.

I was once in a workshop led by a painter who said he had learned much from what he called the "universe principle" of Japanese flower-arranging. Begin, he said, by waiting, by appreciating, the space; space comes before form.

Then, he taught, think of a potential image as having three essential elements. First there is "heaven," the main focus or element of the image. This is what the image is about, what provides its main meaning or value. Then there is a second element—the "earth"—that plays the essential role of grounding or giving context to the element of heaven. Finally, an image that works often contains a third element, the "human," which he described as the "spark."

This "human" element, though secondary, provides an additional spark of life or a surprise, but it isn't the main focus and often isn't apparent without a close look at the image. I have sometimes found this to be a helpful way to think about the composition of an image.

An image usually speaks to us not just because of the actual content but because of the way the content is ordered: how it is selected, how the elements are arranged, how the eye is guided through the image, how light is used, how it is balanced, what metaphors are suggested. This is, in many ways, what Cartier-Bresson has called "giving meaning to the world," and it is an important part of the photographic process.

To take a photograph means to recognize—simultaneously and within a fraction of a second—both the fact itself and the rigorous organization of visually perceived forms that give it meaning. It is putting one's head, one's eye, and one's heart on the same axis.[57] —Cartier-Bresson

Quotations for reflection:

We are in the face of one of nature's most profound mysteries: how beauty and structure arise from a delicate balance of order and disorder.[58] —Chet Raymo

Landscapes have become the conscience of our survival, the measuring devices of how well, or how badly, we are doing. They are the work of organizers, also prophets. There is a religious element in all of them, in that they offer hope.[59]
—John Nichols

Art is a discovery of harmony, a vision of disparities reconciled, of shape beneath confusion. Art does not deny that evil is real, but it places evil in a context that implies an affirmation; the structure of the picture, which is a metaphor for the structure of Creation, suggests that evil is not final.[60]
—Robert Adams

Exercise: Where is the energy?

Purpose: To become more aware of the elements of composition.

Problem: How a photograph is organized or composed determines its visual power and affects its meaning. Some of this may be intuitive, but most of us can increase our awareness and ability by conscious attention to composition.

Materials needed:
- Two L-shaped pieces of cardboard to use as cropping tools. Alternately, in digital photography you could use the cropping tool in your photo software.
- One of the photographs you have made for a past assignment. A black-and-white image may be easier because it reduces the elements with which you have to contend.

Activity:
Part I: Using your cropping tool, experiment with a variety of ways of cropping or composing the image.

Ask yourself these questions:
- Where is the energy in this image? What ways of cropping emphasize that energy?
- What is the effect of the frame, i.e., the edges of the image?
- What draws the eye, and how does the eye move in and through the image? Why?

- What creates the sense of balance? Is it a static or dynamic balance? Symmetrical or asymmetrical?

Part II: Make at least one new photograph creating a sense of balance without having the subject in the center. Then make a photograph in which the dominant line or shape is a spiral or diagonal. While doing this, give attention also to the questions in Part I above.

Reflection/discussion:
- What are the visual and emotional effects of the various ways of composing the image?
- Are there any generalizations or guiding suggestions you might make for yourself?
- Do you sense your preference for a particular way of balancing or composing?
 Additional suggestions:
- Do Part I above using other photographs you made in previous exercises. Reflect on how not only the visual and emotional impact changes, but how the different ways of cropping might affect the overall meaning.
- Make a portrait and crop it very tightly, deliberately cropping out parts of the person. For example, you might photograph the face so that part of it is cut off. Reflect on the impact of this in the resulting image.
- Find a photograph with lots of detail and activity. Cut it into rectangular fragments. Now consider the different ways you could interpret each fragment if you did not know that it was part of the larger picture. Think about the various ways you could interpret the overall image if you did not have an identifying caption.

Exercise: Disciplined seeing

Purpose: To encourage careful and disciplined "seeing."

Problem: We often tend to be sloppy in how we compose an image. We may not be aware of distracting elements (e.g., a tree growing out of someone's head), or we may assume we can make up for mistakes on the computer or in the darkroom.

Activity: Find a space and subject where you won't be distracted by others. Photograph in that space. Be very conscious of composition and assume that you will not crop later—you have to get it right at the moment of exposure. Use what you have learned from the preceding exercise. Try to follow Weston's concept of "the strongest way of seeing." Reflect on the process and also on the resulting photographs.

Reflection/discussion:
- What difficulties and challenges did this pose for you?
- Did this increase your visual and emotional awareness of the subject?

Additional suggestions:
- Do the above exercise, but this time allow yourself only two exposures.
- Make a photograph in which you consciously try to follow the "universe" principle described in this chapter on page 64.

- Try some street photography where you don't look through the viewfinder. What are the strengths and weaknesses of this approach to composition?
- Make a portrait of a friend. Be very deliberate about the setting, the light, and especially the composition, considering what qualities in your friend you want to portray and how you might best portray them.

8.
With Respect
and Humility

Seeing begins with respect. . . . it is clear that no one can truly see something he has not respected.

Seeing nature is a process, partly, of replacing our arrogance with humility. When we respect the reality which fills the abyss of our ignorance, we begin to see.

Seeing begins with respect, but wonder is the fuel which sustains vision.[61]

—Steven J. Meyers

Wonder . . . respect . . . humility. As Meyers notes in the quotes above, the three are intricately intertwined.

In my speaking and writing about restorative justice, and in my teaching of documentary photography and research, I often emphasize the centrality of these values. I am also convinced that these values are essential to a meditative or contemplative approach to photography—and to all of life that is consistent with the creator's intent.

In the word "humility" I include its common usage, the idea of not taking undo credit. But by humility I also mean

something more basic and more difficult: a profound recognition of the limits of what we "know." Such humility requires a real caution about generalizing what we think we know of others' situations. Such humility also requires a deep awareness of how our biographies affect our knowledge and biases.

Our gender, culture, ethnicity, and personal and collective histories all profoundly shape how we know and what we know, and in ways that are often difficult to bring to consciousness. Humility calls us, then, to a deep appreciation for and openness to others' realities and to new revelations.

Humility implies another essential value: respect. My experiences with justice lead me to believe that issues of respect are fundamental to both offenders and victims of trauma and to the negative ways both so often experience justice. Humility and respect are key to the recovery and transformation of both offenders and victims.

As photographers, we must approach our subjects—whether landscapes or people—with respect. It helps to remember, as photographer John Running has pointed out, that all photographs are a kind of exchange or collaboration.[62] And when we collaborate, we have obligations—to treat all respectfully, to be accountable to our subjects.

Respect, humility, wonder . . . such an approach to photography might be called an act of love. "Deeds of charity," Richard Niebuhr calls some of Dorothea Lange's photographs, and continues: "They are the spores from which life spreads."[63] A contemplative approach to photography is an expression of wonder grounded in respect and humility. As such, it calls us to live in right relationship with our creator, the creation, and our fellow human beings. It is an expression of what the Jewish and Christian scriptures call

shalom. It is a reminder of the central value implied by words in so many traditions—*ubuntu* in Bantu, *salaam* in Arabic, *hozho* in Navajo, *Ni mi no hum* in Cheyenne: we are all interconnected.

We come back to where we began, to Cartier-Bresson's observations:

> *For me the camera is a sketch book,*
> *an instrument of intuition and spontaneity,*
> *the master of the instant which, in visual terms,*
> *questions and decides simultaneously.*
> *In order to "give meaning" to the world,*
> *one has to feel oneself involved in what one frames*
> *through the viewfinder.*
> *This attitude requires concentration,*
> *a discipline of mind, sensitivity,*
> *and a sense of geometry—*
> *it is by great economy of means*
> *that one arrives at simplicity of expression.*
> *One must always take photographs with*
> *the greatest respect for the subject and for oneself.*

Exercise: Taking stock

Purpose: To reflect on your experiences and learnings from this journey.

Activity: Look back over your journal and over the photos you made for the exercises in this book. In your journal, explore the questions below. If you have done these exercises along with someone else, the two of you may want to discuss the questions together.

- Are there evidences of respect, humility, and wonder in your images and in the process you experienced?
- If you look at your exercises in chronological order, do you see any trends or patterns in what you have done and how you see?
- Has this process in any way changed the way you imagine photography and the way you practice it? If so, how?
- In what ways has this changed the way you see and/or think about the world around you?
- Are there ways that you might incorporate these approaches and values into your life and work?

Additional suggestion: The process of selecting and editing is a useful one. You might want to select 4-6 photos from your exercises and create a personal portfolio for your journal. As you look at your portfolio, here are some questions to consider:

- What about these photos, individually and as a group, do you like?

- What about them would you change if you were making them again?
- How do you evaluate your visual awareness and skills at this point?
- If you were to continue to practice these skills and approaches, how and in what ways would you hope to develop and to continue as a photographer?

Endnotes

1 In *The Mind's Eye: Writings on Photography and Photographers* (New York: Aperture, 1999), pp. 15ff.

2 *Form and Content* (Chicago: Loyola Press, 1979), p. vii.

3 "Looking Through the Wall: A Meditation on Vision," in *Parabola* (February 1996). Reprinted from "The Search for Meaning," in *Parabola 2* (Winter 1977).

4 In *On Seeing Nature* (Golden, CO: Fulcrum, 1987), p. 102.

5 In *Honey from Stone: A Naturalist's Search for God* (New York: Viking Penguin, 1989), p. 185.

6 See "The Photographer As Aggressor" in *Observations: Essays on Documentary Photography,* ed. David Featherstone (Carmel, CA: Friends of Photography, 1984), p. 7.

7 This historical perspective draws primarily upon Jay, "The Photographer As Aggressor," pp. 7-23, but also on Susan Sontag, *On Photography* (New York: Farrar, Straus, and Giroux, 1977).

8 In *Witness in Our Time: Working Lives of Documentary Photographers,* ed. Ken Light (Washington, D.C.: Smithsonian Institution Press, 2000), p. 158.

9 (New York: Farrar, Straus, and Giroux, 1977), p. 8.

10 See "Flamenco Stories," in *Black and White Photography* (U.K.), (December 2001/January 2002), p. 48.

11 In Niebuhr, "Looking Through the Wall."

12 See http://www.mindfulness.com.

13 In *The Meditative Mind: The Varieties of Meditative Experience* (Los Angeles: Jeremy P. Tarcher/Perigee Books, 1988), p. 20.

14 See "Pay Attention," in *Photo Techniques* (March/April 2004), p. 8.

15 In *Ben Shahn,* ed. John Morse (New York: Praeger, 1972), p. 134.

16 In Phillippe L. Gross and S. I. Shapiro, *The Tao of Photography: Seeing Beyond Seeing* (Berkeley: Ten Speed Press, 2001), p. 70.

17 (San Francisco: Harper and Row, 1982), pp. 5-7.

18 For a fuller discussion of mindfulness and hindrances to mindfulness, see Gross and Shapiro, *The Tao of Photography.*

19 See "A Photographic Portfolio," in *Lenswork Quarterly* (Winter 1996/97), p. 16.

20 See Niebuhr, "Looking Through the Wall," pp. 15-16.

21 In *On Seeing Nature,* pp. 6-7.

22 In *Honey from Stone,* p. 58, paraphrased.

23 (Toronto: Penguin, 1996), pp. 101-130.

24 In *On Seeing Nature,* p. 118.

25 In *My Story as Told by Water* (San Francisco: Sierra Club Books, 2001), p. 88.

26 In *Will and Spirit: A Contemplative Psychology,* p. 6.

27 See Lester Richter, *American Shino: The Glaze of a Thou-*

sand Faces (New York: Babcock Galleries, 2001), p. 78.

28 See Niebuhr, "Looking Through the Wall," p. 8.

29 Pat Koehler, class, Elkhart, IN, 3/30/87.

30 In *On Seeing Nature*, p. 118.

31 Ibid., p. 98.

32 In *Master Photographers*, ed. Pat Booth (New York: Clarkson N. Potter, 1983), p. 111.

33 In *The Shape of Content* (Cambridge: Harvard University Press, 1957), p. 63.

34 From an interview in *Flash Afrique! Photography from West Africa* (Vienna, Austria: Kunsthalle Wien, 2001), p. 79.

35 From the short story, "The Play of Light" by Fiona Farrell, in *Light Readings* (Auckland, New Zealand: Random House, 2001), p. 7.

36 In *On Seeing Nature*, pp. 93-119.

37 Ibid., p. 70.

38 John 12:35 (*New Jerusalem Bible*).

39 On metaphor, see especially George Lakoff and Mark Johnson, *Metaphors We Live By* (Chicago: University of Chicago Press, 1980).

40 In *The Clam Lake Papers: A Winter in the North Woods* (Ellison Bay, WI: Wm. Caxton Ltd., 1996), p. 124.

41 Ibid., p. 29.

42 Ibid., pp. 40, 43.

43 In *On Seeing Nature*, p. 89.

44 Luke 1:78 (New Revised Standard Version).

45 In *On Seeing Nature*, p. 86.

46 In *Crossing Open Ground* (London: Macmillan, 1988), p. 71.

47 In *The Clam Lake Papers*, p. 40.

48 In *The Mind's Eye*, pp. 15ff.

49 (Stanford: Stanford University Press, 1994), p. 11.

50 In *Counterparts: Form and Emotion in Photography* (New York: Metropolitan Museum of Art, 1982), p. 71.

51 In *Walking on Water: Reflections on Faith and Art* (Wheaton: H. Shaw, 1980; North Point Press; Reprint edition,1995), p. 17.

52 In *Why People Photograph* (New York: Aperture, 1994), p. 181.

53 Ibid., p. 60.

54 In *The Shape of Content*, p. 53.

55 Ibid., p. 70.

56 See "Seeing Photographically," in *Classic Essays on Photography*, ed. Alan Trachtenberg (New Haven: Leete's Island Books, 1980), p. 175.

57 In *The Mind's Eye*, p. 16.

58 In *Honey from Stone*, p. 57.

59 In the introduction to *The Sky's the Limit: A Defense of the Planet* (New York: W. W. Norton, 1990).

60 In *Why People Photograph*, p. 181.

61 In *On Seeing Nature*, pp. 5-7.

62 In *Pictures for Solomon* (Flagstaff, AZ: Northland Publishing Co., 1990), pp. 2-3.

63 In Niebuhr, "Looking Through the Wall," p. 18.

Readings and Sources

Adams, Robert. *Beauty in Photography: Essays in Defense of Traditional Values* (New York: Aperture, 1981).

_____. *Why People Photograph* (New York: Aperture,1994).

Bayles, David and Ted Orland. *Art and Fear: Observations on the Perils (and Rewards) of Artmaking* (Santa Cruz, CA: The Imaging Consortium, 2004).

Cartier-Bresson, Henri. *The Mind's Eye: Writings on Photography and Photographers* (New York: Aperture, 1999).

Coles, Robert. *Doing Documentary Work* (New York: Oxford University Press, 1997).

Gross, Phillippe L., and S. I. Shapiro. *The Tao of Photography: Seeing Beyond Seeing* (Berkeley: Ten Speed Press, 2001).

Heschel, Abraham Joshua. *I Asked for Wonder: A Spiritual Anthology* (New York: Crossroad, 1983).

Jay, Bill. "The Photographer As Aggressor" in *Observations: Essays on Documentary Photography,* David Featherstone ed. (Carmel, CA: Friends of Photography, 1984).

Lakoff, George and Mark Johnson, *Metaphors We Live By* (Chicago: University of Chicago Press, 1980).

Marty, Martin, and Micah Marty. *The Promise of Winter: Quickening the Spirit on Ordinary Days and in Fallow Seasons* (Grand Rapids: W.B. Eerdmans Publishing, 1997).

May, Rollo. *The Courage to Create* (New York: W. W. Norton & Co., 1994).

Meyers, Steven J. *On Seeing Nature* (Golden, CO: Fulcrum, 1987).

Shahn, Ben. *The Shape of Content* (Cambridge: Harvard University Press, 1992).

Sontag, Susan. *On Photography* (New York: Picador, 2001).

About the Author

Howard Zehr is internationally known for his pioneering work in restorative justice. His book *Changing Lenses: A New Focus for Crime and Justice* (third edition, 2005) is considered a foundational work in this field. *The Little Book of Restorative Justice*, the first in this Little Book series, provides a short overview of the theory and practice of this field.

Zehr's vocational and avocational passion in addition to justice is photography. He has worked part-time for many years doing a variety of freelance and journalistic photography projects, including international photo work for Mennonite Central Committee (MCC). He also enjoys landscape and portrait photography. His work has been shown and published in a variety of venues.

He is particularly interested in documentary photography and interviewing. Recent books in this genre include *Doing Life: Men and Women Serving Life Sentences* and *Transcending: Reflections of Crime Victims,* both published by Good Books.

Zehr is Professor of Restorative Justice and currently also Co-Director of the Center for Justice and Peacebuilding at Eastern Mennonite University, Harrisonburg, Virginia.

METHOD OF PAYMENT

❐ Check or Money Order
 (*payable to* **Good Books** *in U.S. funds*)

❐ Please charge my:
 ❐ MasterCard ❐ Visa
 ❐ Discover ❐ American Express

\# _____

exp. date _____

Signature _____

Name _____

Address _____

City _____

State _____

Zip _____

Phone _____

Email _____

SHIP TO: (if different)

Name _____

Address _____

City _____

State _____

Zip _____

Mail order to: **Good Books**
P.O. Box 419 • Intercourse, PA 17534-0419
Call toll-free: 800/762-7171
Fax toll-free: 888/768-3433
Prices subject to change.

The Little Book of
Contemplative Photography
ORDER FORM

If you would like to order multiple copies of *The Little Book of Contemplative Photography* by Howard Zehr for groups you know or are a part of, use this form. (Discounts apply only for more than one copy.)

Photocopy this page as often as you like.

The following discounts apply:

1 copy	$4.95
2-5 copies	$4.45 each (a 10% discount)
6-10 copies	$4.20 each (a 15% discount)
11-20 copies	$3.96 each (a 20% discount)
21-99 copies	$3.45 each (a 30% discount)
100 or more	$2.97 each (a 40% discount)

Free shipping for U.S. orders of 100 or more!

Prices subject to change.

Quantity *Price* *Total*

_____ copies of *Contemplative Photography* @ _____ _____

Shipping & Handling
(U.S. orders only: add 10%; $3.95 minimum) _____

For international orders, please call 800/762-7171, ext. 221

PA residents add 6% sales tax _____

TOTAL _____

800/762-7171 • www.GoodBooks.com